Syzygy
Poems of Essential Theory

Brad Dehler

TROIKA PUBLISHNG
SALEM, OREGON

Syzygy: Poems of Essential Theory

Copyright © Brad Dehler 2020

ALL RIGHTS RESERVED. No part of this work covered by the copyright herein may be reproduced, transmitted, stored, or used in any form or by any means graphic, electronic, or mechanical, including but not limited to photocopying, recording, scanning, digitizing, taping, Web distribution, information networks, or information storage and retrieval systems, except as permitted under Section 107 or 108 of the 1976 United States Copyright Act, without the prior written permission of the author.

Printed in the United States of America
First edition

Additional copies are available at
Barnes and Noble
Books-A-Million
Ebay

or www.Amazon.com

For product information, permission to use material from this text, or further permissions questions- please e-mail to: Troika7@gmail.com

A special thanks to the formatters at CreateSpace
and for the encouragement from Kindle Direct Publishing KDP.
Book design, images and layout: Brad Dehler

ISBN-13: 978-0-9829733-2-5
ISBN-10: 0-9829733-2-2

Troika Publishing; Salem, Oregon
Printing by KDP/CreateSpace; Charlotte, South Carolina
An Amazon Company
USA

Other Troika Publishing books by Brad Dehler:
Cantus: A Book of Poems
(ISBN-13: 978-0-982-9733-0-1 & ISBN-10: 0-982-97330-6)
http://www.amazon.com/Cantus-Brad-Dehler/dp/0982973306/

Dose: Poems of Quintessential Ethereality
(ISBN-13: 978-0-982-9733-1-8 & ISBN-10: 0-982-97331-4)
https://www.amazon.com/Dose-Quintessential-Ethereality-Brad-Dehler/dp/0982973314

"In his work, Brad takes the reader on a soul-searching journey both provocative and intriguing. The choice and use of words, like a fine-tuned instrument elicits an invitation to see beyond the surface. His poetic expressions are a kaleidoscope of life's experiences and desires. There is an honesty about the strength and frailty of the human spirit. The reader can relate to the uncertainty about life and the need for a sense of place and belonging."

-**Kay Loraine** Florence, Oregon
Poetess, decorated Art Therapist, mental health guru & Collagist

*

INTRODUCTION
Syzygy

Welcome to Syzygy. Thank you for choosing this book. This is the third book of poetry in Brad Dehler's repertoire, proceeding the books Cantus & Dose. A syzygy is an event where the sun, earth and moon align; metaphorically a time when we are aligned with our purpose- soul, body and mind. When, not only all is right, but when it is the time most opportune and we are to be ready.

In regards to Troika Studios & Publishing: The vision of a guiding troika arose in Brad's mind while evacuating as a refugee from Hurricane Katrina. He embraced this concept as a driving force, as opposed to a passive beacon, in regards to developing his vocation. The significant reassessment of his location in Past, Present and Future; the use of Poetry, Painting and Drawing in his life -unfurled.

Compared with other poets considered important to any canon- Brad does not pay, in any particular conscious way- attention to traditional use of rhyme, form or literary devices. Rather- the process is very subconscious and kept in very much its raw form. In this way, many trifectas turned triumvirates. Brad feels the importance and believes it is his calling to then share these words of revelation. In hopes they are a light in the dark; leading us through. A tool to help us advance, a foothold to help us grapple. All these things for US, Brad too must heed these challenges and remind himself of mission in compliance with truth. Appreciation, seeking truth- to serve others.

*

SYZYGY
Table of Contents

New Journey	13
Paper Tigers	14
Hunger Was the Life	15
Wine Pairing	16
Every Season	17
Morning Prayer	18
About the Trial	19
Ghost Dance	20
Close the Kingdom	21
Hope they Say	22
Mare Running at Night	23
Soft Soul	24
Your Life is Bigger	25
Cobra on Surfboard	26
Energy Pools	27
Satisfaction is from the Heart	28
It Wasn't a Dream	29
Yearn for Your Gaze	30
Near-Infinite Angles	31
Good River	32
Where the Bullet Lies	33
Scope of Influence	34
How Far is Too Far	35
I Saw the Richat	36
Pole My Decisions	37

Words Like Paint	38
All or Nothing	39
Butterfly Will Do the Same	40
Shadows Casted	41
Empty My Hands	42
In Hope We Stride	43
Soaking Fuel Into Soil	44
Sleeper Cell	45
This City	46
Self-Indulgent-Centered	47
Truth Evermore	48
Rebirth	49
Suspended We Grapple	50
For Discipline	51
Tramp Steamer	52
Massage a Bruise	53
Reverse Apparition	54
Modern Trend	55
Divine Light	56
My Mind is Amiss	57
Gut and Heart	58
Troika II	59
What Stars We Are	60
Wonderment Binges	61
Pheno-typicals	62
Sweet Orbiting Outside Myself	63
Shakespeare Labored	64
Entire Room Warmed	65

Artificial Confidence	66
Engaged to a Tombstone	67
Pyres of October	68
As Classical Music	69
Infinite Offense	70
From the Dirty-dirty	71
Let There Be a Gem	72
And True for Prayer	73
Find Peace	74
Death is Imminent	75
Drenched From Years	76
Mitakuye Oyasin	77
Coup of Dove	78
Love is Bigger Than You	79
Sober Days	80
Star-Bird	81
Ideals Up	82
Humility Kick In	83
All Illusion	84
The Forest Changed	85
Wrongs Argued	86
B' The Lake	87
Cross Hatched	88
Title of This Poem Pending Review	89
Cross and Close	90
Love is Alive and Dead	91
My Love from Above	92
Needs Renewal	93

Errror as Mentor	94
Allowance of the Divine	95
Hell Will Compel	96
Scraping Eyes	97
Chasing a Dream	98
Rez Dog	99
A God Among Atheists	100
Shelter Follow Me	101
On the Path	102
Position to Win	103
Medicine Bag	104
What a Dream!	105
Felled Trees	106
Rust Colored Blood	107
Spectating Planets	108
De-Remember	109
Metaphor For Metamorphosis	110
Pennings in Darkness	111
Don't Start Struggling Now	112
Sound Notion	113
Memories are Later	114
To Find Peace	115
Lost My Shirt in the Deal	116
Valley is Low	117
Callous Hands	118
Dog Eat Dog	119
Wait of Time	120
No Reason to Seek	121

Sleep in Your Eyes	122
Brad Looks Twice	123
Moving Up on Any Map	124
Unfertile Grotto	125
Shadow Relentlessly Follows	126
Foolhardy Heart	127
Tampering Light	128
Casual Dehumanizing	129
Whimper	130
Diversion from Own Path	131
I Think I Know	132
Dirt in My Hand	133
Regarding Irregardless	134
Path Jagged	135
Knoll in the Plain	136
Scepter-Sword	137
Life Like a Ripcord	138
Cities of Origin	139
Cannot Recall	140
Oft the Latter	141
Magesty of the Human Spirit	142
Forgone Result	143
That Flabbergsted Grey	144
When All I Feel is Spent	145
Without Moderance	146
Ribs Cradle Cryptic Gifts	147
Sleep Be the Thief	148
Razor Burn	149

Here is to you
On your new
Heart felt,
 Head bent,
 Liver quenched
Journey

Salem 08.20.2018

*

Drive into Friday
 Smell the midnight field
Reveal yesterday's
 Sun and Summer shower
Dark road, paper tigers
 Stash pen
Cloud-mountains
Dread the path
Until revelation road

Modoc Forest, CA 06.25.16

*

Bellies full
Mouths a-grin
Eyes glazed
Over the final course
Hunger was the life

Salem 04.12.16

*

Wine paring with my art
Both subjective
 Of varied flavor
So give more wine
To the subject
To solicit favor

Salem 5.18.14 0124

Repeat Repentance
Because it is in our nature
Need for reminding
Renewal every season

Gardnerville, NV 6.26.2016

*

Bless the clients
Bless this house of counsel
And bless me
 The clinician

Salem 2017

So many ways to convey
I am sure you are relieved
 About the trial
The judge was mistaken
Jury confused
Are you relieved?
Wrong decision, good outcome
Good decision, good for you
Bad for society

Prison in decision
Prison indecision

Salem 10.09.19

The coming summer shower
In the Mesmer ozone
Blurred headdress motioned
Ghost dance with
Crow primaries
On hallowed ground
Ancestors lost
We seek gain; a living

Modoc Forest, CA 06.26.16

*

How close the kingdom
Roles be blessed
Royal aspiration pushes away
 Pushing off of
Though kingdom is in your name
Ancestors take your namesake
Close indeed, kingdom inside you

 Salem 6.26.2018

I hope they say
'You brought brightness
 and light'
To the perimeters
And clarity to the core

Salem 7.10.19 @1402

*

A mare running at night
Ominous omens surrounding me
A mayor running in delight
No good coming from this
Representative of only yourself

Eugene, OR 05.24.19

Hardened heart
 To protect
Your soft soul
Self-sabotage vs sacrifice
The peril
Of survive
Over thrive

Salem 05.20.2016

Focus on the Truth
Rather than patents
Or other refinements
Your Life
 Is bigger than you

Salem 09.25.19

*

Cobra on surfboard
Find your center
Align heart over center
Head over heart
All in order
Heart over everything
In the present
Head for the future
Gutted in the past
As well as for reflex
Focus on your breath

Bend, Oregon 10.08.2016

*

Rivers- good and necessary
But where is your lake?
Where your ocean
Where this energy pools
Defines your depths

Salem 12.04.2016

*

Satisfaction is from the heart
Dislocated in things
There is always
The possibility of
Dissatisfaction
Thinking 'one more'
'Something new'
Mind is insatiable
Devour knowledge
Thin line of aggrandizement
And enhancement

Salem 10.20.2017

*

It wasn't a dream
It was a vague memory
From my fickle mind
Over tricky fingers
And slighted hands
Having trouble tracking
No, it wasn't a dream

Salem 08.12.2020

Bless my attention
En route to understanding
Comprehension of urgency
 And
Not to forget memory
I yearn for your gaze
Please that look
 Upon me with favor
To listen, please teach
In other words, sanctify

Castle Rock, WA 03.03.17

*

Before I was told about the ways
I was talking to eternity
We live in a world
 Of near-infinite angles
 From point to point
The possibilities confound us
Infinite from
 Our inability to process

Salem 10.30.17

*

Good river
Flow with liquid force

Good or bad
Experience merges with our being
Accused of running away
 Or hiding
Perhaps some are cleansing
 And starting anew

Salem 03.03.18

*

The truth where the bullet lies
Or where it has gone through
Critical origin
"Why fret"
The bullet no longer in you
"It's over"
It's not

Salem 01.20.2020

*

Accepting dirt on your hands
Contaminates your inner being
You now see it on you
Then corrupted your thoughts

Do not be preoccupied
Lest you consumed
Do not belittle
 Your scope of influence
They need you
If abandoned for personal glory
 You fail all

St Sharbel Portland, OR 03.05.2017

*

How far is too far
Where we draw the line
Sometimes
Count the ways
Count the days
A million blinks
Or a single life

Salem 04.16.18

*

I saw the Richat
It looked back
I could now see
In me
What I could not see
Previously

Salem 03.06.2020

*

If only I could pull
Andy Warhol into the discussion
Yet more from Thomas
Aquinas dissertation
If only I could poll my decisions
If only I could pull
In-from the heavens

Salem 04.23.2020 @ 0139

*

Rhyme words like paint
Clash bad
Bright and inviting attractive
Able to coat to appear
 Two things are alike

Castlerock, WA 11.04.2017

*

It's all or nothing
Happens every time
Followed you to
 The threshold twice
The wound is gushing

Salem 12.30.2015

They always
Say
Like a moth to a flame
But a butterfly
Will do the same

Salem 05.11.2016

Shadows are not born
They are casted
Existing because
 There is a light source

Salem 08.27.2019

There are things I must lay down
 Now
Things I carried
To enable my trek here
But now I empty my hands
To grasp my new objective

Salem 08.06.2020 0234

*

We are on the edge of the world
Reconciliation is a map back
Hour of our death
Mile-marker
In hope we stride
In stride we heal

Castlerock, WA 11.04.2017

*

Soaking fuel into soil
Render both useless
To our need
Prayer chain smokers
Hoboken chokin'
Dimming twilight stage
 Of life

Salem 10.16.16

Inside us all
That sleeper cell
That accepted dose of poison
Far more unstable
 Than our facades let on
Then there is the one
That cracks or explodes
We find our decoy

Salem 10.14.19 @0203

*

This city
It breaks you
It makes you
 Want to fold
Guilt gilded on you
Grace may be hastened from you
Heart of gold
Silver soul
Mettle of your mind to keep it
 All together

Seattle, WA 07.15.2018 @1238

*

The self-indulgent-centered
Ask of many things

The one predictor
Inquire
 About wants and needs

Salem 11.12.2017

Often we have stories
By storytellers
Who have agendas
What happens to truth
When the one with true memory
Passes
 And
The remnants of false remain
Assuredly
There is the truth
Evermore. Unchanged

Salem 04.29.2018

Boy to juvenile to man
To family father
Rebirth

Salem 08.12.2018

I reach my art
Pumping blood
My song my paint
My charcoal my poems
I recognize yours
You reject mine
I reject you
You reject me

And separate we float

Suspended- we grapple
 We are grounded
When we gravitate to good
Our stories again intermingle
What is mine is ours

Salem 08.12.2018

*

Talk of selling album blank
Shows that it has
 The same message
Nothing
May you keep admiration
 For discipline
May all your doubts
 Remain curious
All your good will
Hopeful

Grand Ronde, OR 08.24.18

*

Catch a random ride
On a tramp steamer
Spontaneous on my balms
Dispersing dollars by palm
Pushing my perspective
Then
Relaxed
Rolling back
On hindfoot for healing

Salem 02.19.19 0123

*

Massage a bruise
Will not comfort the discomforted
I'll sing the same song
The same way
For my own recognition

Salem 08.24.2019

*

Perhaps we are the ghosts of
The reverse apparition
The flinch image
The flicker in the mirror

Salem 11.26.2018

Modern trend
Is the further separating
 The terms
Grievous and egregious

Salem 11.06.16

*

Shine upon me thy divine light
Whose gentle rays harass darkness
The present tense of
Won is win
One is when
If I could have been there
In that moment of devastation
As you are
Now, as you were
Belief you are nothing
Lost worth
Though in pursuit of truth
I can see your pain
By your display
In your art or anger
I can hold it for ransom
Until your return

Castle Rock, WA 02.02.19

*

Been howling at the moon
Discontented
No body hearing
Cried out the side
Of my eyes

My mind is amiss
My soul an abyss
But all goodness
Makes it a plentiful receptor
That much more
To hold graces

Salem 10.12.2018

*

Resemblance is not mimicry
Our trunk resembles a snake
Contains our gut and heart

Salem 09.07.2019

*

Troika
The two horses
Of which I am aware
 Driving
Dark horse
 Takes lead
Least considered

Salem 09.07.2019

*

You ask what stars we are
Beyond mere celebrity
Gaze into the deep black beyond
Contrasted by their glimmer
We traveled far
To now be near each other
So the stars we are
Not the ones in similar proximity
But
The two brightest close
 In counterbalance

Pacific City, OR Summer 2000

Every day is a new day
Until it is not
A new day old from routine
Ripe for retirement
On that pathway, hinges
Your wonderment binges
 Of fanciful fruit
Possibilities plucked, glimmering

Salem 5.26.16

*

Grudge held
Being wronged was whitewashed
Across all pheno-typicals
You are going to die
By the bite
Of your ancestors

Salem 10.18.2019 0739

*

The ethyl center of the
 Milky Way
Raspberry rum on the tongue
Pull me outside my centeredness
The barycenter
Sweet orbiting outside myself

Salem 09.16.16

Shakespeare labored
To explain our kind of love

Salem 10.12.16

*

I find solace in the cry room
Despite- I am not crying
Entire room warmed
 By my presence
Faithfulness for the faithless
Goodness without witness
Reduction of God to bite size
Morsel enough (Save you)
Affliction avoided by infliction
(Bathe you)
Scar bestowed
Asleep, I was caught in the wake

Newport, OR 11.09.2019

Sure as unpredictable is
I lost it all in my mind
Confidence is artificial
Until it lays impression
Slays doubt

Salem 04.06.2017

*

As foolish to be
 Engaged with a tombstone
Than in conversation
 With a fool

Salem 10.12.16

The pyres of October
Alit in November
Led to Embers
 By December's end
Now why do we tremble
In this season's preamble
From plight
 Of winter's frozen night
Or the bon fire
May turn
 To conflagration
(Pyro) pyrrhic victories
Here ye; Hear-see
We need warmth, give us shelter

Here-say
Months of dismay

Salem 10.20.16

*

She is beautiful
As classical music
Surrounding me
With a lovely string piece

Salem 06.19.2019

*

Infinite offense against
An infinite soul
A child abandoned
A man never known

Salem 2.14.2017

*

We reckless
We sightless
From the dirty-dirty
You heard me
You're sure to get shot
Triggers rep a rap sheet
Just as long as your block

New Orleans 2004

When supply is low
The leftovers low quality
When we are in deprivation
Please good shepherd
Good current guiding
Let there be a gem

Salem 09.18.2016

*

Proceeding through
Half-hearted
Renders one resentful
Be it
 Cadet not to be police
 Artist not fully realized
 Sportsman only dreaming
And true for prayer

Salem 06.02.2020 @2020

*

How can one find peace
When one has lost
 So many pieces

Salem 06.21.17 @ 2122

Death is imminent
Just around the coroner

Salem 5.14.2020 @1202

*

Flesh lays on my face
Will eventually droop
Drenched from years

Hill AFB, Utah 1998

*

Let us speak in direct lines
Avoidant of seductive
 Curved, pleasantries
Let us appreciate what we are
 What we have
And put to best use
To become all we can
So we say
Mitakuye Oyasin

Salem 01.15.18 @1940

*

Claim to be a dove
Calling "coup, coup"
Warhawk semantic mimicry
Shift away from populous
 Chicken coop. Pituitary
Lie when you rest
Stand where you are

Salem 10.15.2019

Love is bigger than you
Love your husband,
Your wife,
Your sister,
Your brother,
Love your father,
Your mother
Love before yourself
Love is capitalized
You put after love
 Love is
Love within yourself, then
Your love can
Exist in a multitude
 Of others
Beyond self

Portland, OR 04.01.12

The sober days are
Numbered days
The somber days are
Over days
The tortured days
Are nights

Salem 10.16.2019

Star-bird
Love written word
But comfortably in the sand
Perched on right hand
Like Phoenix but without death
Coo dove gentle breath
Need not resurrect
Rest, now, with me here
Pardon as I bend your ear
Recompense
Patient for me
I will return as a listener
Parallel, disarming
Blissfully in the ether
Present- my heart

Salem 01.20.2020

*

Ideals
Up for attack
Far more for guilt
Than inadequacy

Portland, OR 09.11.2009

Note some humility
Kick in
Beware the ego
Kick out

Salem 06.20.16

You say
'There is no time'
Did you mean
Time ran out
Time is up
Or
Never there was
 All illusion

Salem 03.16.2020 @2323

*

The forest changed
But slower than the ocean shore
Recognizable for long
 Stints of time
You are like the ocean
Your personality makes
So that I do not
 Really know you
The ebb and flow of tides
Shaped you strangely

Newport, OR 01.27.2019

The wrongs will be
Argued through the night
For none concerned
The right

Salem 07.12.16

*

A home in the wood
As well as b'the lake
B'the bridge
Heart b'the head
Feel my hand in the dark

Salem 05.15.2019

Cross hatched shady plan

Salem 09.28.2018

For as long as I'm short with you

Salem 05.19.2018

*

I cross my heart
And
Close my eyes

Salem 10.17.17

*

Love is alive and dead
Dead when dead in you
Love for life
Alive and well
When love exalted
Marriage- fidelity to that
Never compromising
That which you
 Protect with all your being
That is how it is greater
Than our flawed humanity

Portland, OR 09.11.2009

*

Better be better to me
Better be better than me
The youth stands on the
 Sturdy father's shoulders
Driven by mother's nurturance
Thinking of
My love from above

Salem 07.17.2020 @2355

*

Love is only for a moment
Then needs renewal
In between
 The bliss so sweet
And Dedication
When conflict
Afflicts us

Salem 04.05.2018

When sole reliance
On experience
 To guide you
You accept error
As mentor

Salem 10.06.2008

What is holiness or hedonism
 Without help
Heaven
Whispers condemned to intention
Or elevated to assertiveness
Prayers ascend us
By at least calibrating the mind
All the way
To the allowance of the divine

Vancouver, WA 11.17.2018

Dread if Heaven
Cannot help
Hell will compel

Salem 08.02.16

The contacts between the lines
That lies between the lies
The truth between our minds
Scraping eyes
With Satan

Salem 09.20.2018

*

Chasing a dream
Running from yourself
With hopes
That self and dream
 Merge
At the place of dreams
Please not Oneirophrenia

Salem 12.06.2019

I am just a downed-luck
Rez dog
Stranded on this land
 Allotted to me
From nomad
To force-fed

Portland, OR 2010

A god among atheists
The God
A/The -ists
Impressed by self, leaves
 No room for impressions
Raptured within being

Salem 04.23.2020

Shelter follow me
Food nourish me
Clothing enwrap me
Love reign within me

Salem 10.11.2018

On the path to holiness
It is beyond dirt capabilities
It is that owl perched
 High above
 Yet connected
We must seek forward
Unfocused, feel inadequate
Precarious
Misinterpreted,
 Pull for betterment
Calibration to that path

Salem 01.12.17 0859

I am in a position
To win
 Because I have been
In a disposition
Of loss

Salem 02.22.2020

Medicine bag
Hangs around neck
Next to heart

Portland, OR 01.17.2017

Oh!
What a dream
It's been
To be alive

Salem 08.10.2016

Felled trees
That propelled our dreams
Which united schemes
And hailed pleas
Hallowed out of ice
That revolved thrice
Which burned the patience
And defined our station

Salem 03.30.2016

Rust colored blood
Cannot save it 'til I'm done
Got to rush, got to gun
Sparkles as it runs
Flat tone as it dries
Darkens as I die

Salem 08.14.2019

*

Spectating planets
Through our own atmosphere
Staid life
Stay woke
There is trauma
It is an emergency
Don't close your eyes
They may not reopen
That zone
 Became a limit

Salem 09.26.2019

*

Re remember
Deremember
De-December
At the end of the cycle
Do not dismember
Ripe and ready rendered

Salem 03.14.2018

Metaphor for metamorphosis
Abounds
Sought meaning
In the queries
Quandaries footed quagmire

Salém 11.04.2019

*

The sun up in grand entry
Magnificent again in setting
In between
 My pennings in darkness
I hold out for next light
I promise to later
 Pay off my sleep debt
All still in the oranges
Striated with wispy cloud
Resolution fulfilled in honoring
Each glorious morn & retirement

Salem 03.24.2019

Don't start struggling now
I need you
I need you- I need you
Don't start struggling now
I got my hands on the wheel
But my eyes misread
Don't touch struggling now
The lyrics come to
 I sing to myself
Don't start struggling now
Dropping into the mire
 And
I'm two feet deep
Struggling now
 I tell myself
While I fear the worst

Salem 03.06.2020

*

Let us not lose sight
Of the sound notion
To forage the food within grasp
But I look past the glass
To a bigger world
I cannot reach it
But it is my tale to share
Conceiving of things
Realized and fulfilled
Without yet beyond bound

Salem 05.27.2020 0127

*

What does it take
To take a moment
In waves rolling over you
Still external

Breathe deep. Take five.
Hang five
Hold a pose
That you can propose later
Take a stance
 To return
To this circumstance
Never to be recreated
Do not fool yourself
Now is now
Memories are later

Newport, OR 01.25.2019

*

To find sanctuary
To find peace
Go to Salem,
 OR
Go to Solemn, Mass.

Salem 5.20.2020

I lost my shirt in the deal
Yay the hanger holds my place

Salem 08.24.2019

*

My hope is high
Though my luck is low
My well is dry
Though the valley shadowed
Though the valley is low

Dallas, TX 09.20.2005 0950

*

Callous hands
To handle more
Tolerance in adversity
So that experience is gainful

Salem 08.10.2018

In this dog eat dog
Rat race
Or frog versus frog
World- however you perceive it
I'm not a consumable

Salem 09.10.2019

*

Eyes not foreseeing
The wait of time
Over the seeming ton of years
Been a long winter
In this hinterland
Yore lore golden
Classic music plays
In my newfound transition

Salem 03.02.2016

*

Any other woman but you
An other woman
Another woman
There is no reason to seek
Any woman other than you

Flower Mound, TX 09.18.2005 0200

Doing regrettable things-
Sleep in your eyes

Salem 01.18.2019

Brad Looks Twice
One muddy, rocky road
One smooth paved road
The poor -tough down the rocky
Muddy if caught in the turmoil
The ease of the smooth
Delivers one soft and content
The one
I would not wish upon
Anyone

Salem 05.29.2020 1034

*

When feeling down
Keep moving forward
That Way
Moving up
On any map

Salem 12.20.2019

Unfertile grotto
 Of Adonis
Let us escape
Jettison- out route
God writes straight
On crooked lines

Covington, LA May 2004

I tread in silence
Not to assume
 Or indict
 Nor indicate
 To acquit
 Or vindicate
Still the shadow
Relentlessly follows
And the smoke chases me
Faulty memory displaces me
Challenging devotion
 To my creed

Salem 01.11.2008

*

Foolhardy foolish heart
Quakes tempest
Shakes my vessel
Born mortally wounded
Fundamental problem
Onward we struggle

Salem 07.01.2018

*

They made hobbyist of my heart
Collector of my bones
Soothsayer of my habits
Beacon to my faults
Soliciting silence by what shone

Temperate light moderately posed
Tempering light strong exposure
Only tampering light pre-exposed

Salem 11.26.2016

*

Problematic in casual
 Dehumanizing
Depersonalization
Did she give birth
 To a boy or to her son?
Give birth to a girl
 Or to the world?
Liable am I now

Salem 04.23.2020 @ 0119

*

Whimper
Think you are the victim?
World coming to an end?
Plead for psychiatry
Excusing your sins for disease
Look unto yourself
Better make a check

Travis AFB, CA 07.21.1994

Live and teach
Upon the one true path
But do not wait in idle
 Expectation
Leave result to trust
For a man will resist diversion
 From his own path
To honor his own choice

Salem 12.17.2007

*

```
I think
I know this
This I know
I think I know
I feel
I feel I know
I know I feel,
    I think
```

Salem 03.19.2019 @0249

*

I want to reconnect
With the world
The object that gets me
That much closer to the heavens
From my personal abyss
Sit and look
At the dirt in my hand
As I did in youth

Salem 07.26.2019

*

No matter the platform
 On which you stand
Irregardless of your
 Perceived power
Regardless of your
 Own weight
You cannot lift yourself
 Up with your platform

Salem 04.13.11

*

My path has been jagged
The rains ceaseless
Every move is aching
I lament my discarded trust
Invested in a world
 Where now
The only kind of peace known
Is Death

Salem 03.15.2011

In the big broad plain
Things look all alone
Stay by my side
I will show you home
I will show you past
 This grassy knoll
Tune the noise to harmony
It's the dust
 That shows your past
It's the waste
 That attracts the rats
My swollen feet mock surprise
Journey for a cure
 Got healed along the way

Travis AFB, CA 07.09.1996

Quick- tell us a story of triumph
Many have there been times
Of affliction, war, forlorn
Now is the era
To open our narrow scope
We are on the edge of despair
Charge forward with torches
Leading with scepter-sword

Salem 07.29.2008

*

My life is
Like a ripcord
Done in a flash
Apogee
Effigy
Refugee

Salem 03.16.2020

*

Your cities of origin
Fail you
Miscreants froth from settlers
Go to soil fed roots
Red dirt
Shaping clay

Salem 08.18.20 @0140

Short is my sleep
I cannot recall my dreams

Salem 07.12.19

Serve me or fail me
My memory oft the latter

Salem 02.09.19

*

Hope that these words
Look you in the eyes
Becoming composition
From provocative words
Nearing the majesty
 Of the human spirit
That presence
 In Person

Pleading in the second stanza
Challenging desire
Mind grind
Path of destruction

Learn the dangers of the wild
Wandering away
But within the wild, safe
Beside a beast

Salem 06.29.2019

*

Foregone result
When knocked on your back
Tears flow
To the ears
When facing trauma
Remaining standing
Tears flow to the mouth

Salem 05.30.2015

*

That flabbergasted gray
"They are killers"
"Everyone's a killer"
Blend metaphors
Demote change
Promote apathy
Destroy meaning
That flabbergasted grey

Salem 04.13.2020 @1009

*

Dissent or assent
Descend or ascend
When all I feel is spent
Crooked eyes bent
Unlifted for compassion
When the culled passion isn't.
All I know is I am sent

Salem 05.07.2020

*

Without moderance
Pleasures become vices
For some, once is excess
Paid too much for that price tag

Salem 10.03.2008

My ribs cradle
 Cryptic gifts
Parochial in my sickness
I am vitalized
I know about the
 50-pound halo
All this sanctifying
Starvation preying on my mind
I am a deadbeat father
Of the 3rd world countries

Fairfield, CA 05.26.1996

Though sleep be the thief
Of my consciousness
I want you beside me

Corvallis, OR 02.16.2003

*

It's that razor burn
Chance to learn
It's that winced morning
Fair warning
Avoidance of
The catastrophic eve

Salem 07.09.2019

THIS PAGE INTENTIONALLY LEFT BLANK

Port Tree
Poe Tree
Poe In Tre
Poor Tree
Paw Tree
Pawtry
Tawdry
Opoetry
Oetry
Put try
Poor Try
Po Dry
Poedry
Potry potpourri
Poet y
Poe It Try
Poet Ree
Pot Ree
Struck by the Ree
Poe in Salem
P03
POE
Po Etty
Poa-try
Pour-try
Pour-tri

Other Works

- *Cantus: A Book of Poems. CreateSpace Publishing.* December 2010. ISBN 978-0-982-97330-1. Cantus-Brad-Dehler/dp/0982973306
- *Dose: Poems of Quintessential Ethereality. CreateSpace Publishing.* November 2016. ISBN 978-0-982-97330-1. Dose-Quintessential-Ethereality-Brad-Dehler/dp/0982973314

www.ingramcontent.com/pod-product-compliance
Lightning Source LLC
Chambersburg PA
CBHW030749180526
45163CB00003B/955